JAPANESE
KIMONO
DESIGNS
COLORING BOOK

MING-JU SUN

DOVER PUBLICATIONS
GARDEN CITY, NEW YORK

D1254675

Even those who know little about Japan will recognize the kimono as a symbol of Japanese life and culture. Based on the *pao,* a Chinese robe that became popular at the Japanese court in the eighth century, the kimono originally was made of silk and silk brocade. Today, cotton and synthetic fabrics such as polyester and rayon are commonly used. For centuries, a kimono was designed to indicate the wearer's age and social standing; in addition, specific patterns were dictated by the season. Modern Japanese may freely select a kimono according to their personal taste, rather than following traditional dictates. Once a feature of everyday life, kimono now are worn mainly for special occasions. And although kimono styles have changed over the centuries, one thing remains constant: the kimono is always wrapped around the body left side over right.

One of the delights of the kimono is the variety of patterns and motifs used by its designer. The Japanese love of nature is conveyed through floral patterns (cherry blossoms and chrysanthemums);

animals; flowing water; and leaves and vines. The seasons frequently are depicted: foliage and spring flowers. Other popular design elements are geometric patterns and repetitive patterns such as the basket weave. Look carefully at the coloring pages and you will find typical accessories, such as hair ornaments—*kanzashi*—and *zori,* footwear with thongs made of cloth, leather or vinyl, or brocade, as well as fans, parasols, and hats.

Four terms relating to the kimono are *furisode, kosode, yukata,* and *obi.* The *furisode* refers to a kimono with extremely long sleeves. In contrast to the furisode is the *kosode,* which has smaller sleeves. Many men and women in today's Japan wear the casual *yukata,* a lightweight cotton summer kimono. Indispensable to the kimono is the *obi,* a sash that wraps around the waistline to securely fasten it (the kimono does not have fasteners such as buttons).

As you provide the color for these astonishingly detailed kimonos drawn by artist Ming-Ju Sun, you will begin to appreciate the timeless beauty of this quintessential Japanese garment.

Bibliographical Note

Japanese Kimono Designs Coloring Book, first published by Dover Publications in 2013, is a republication of the plates from the previously published *Japanese Kimono Designs Coloring Book* (Dover Publications 2007). An additional plate has been included.

International Standard Book Number

ISBN-13: 978-0-486-49344-2
ISBN-10: 0-486-49344-X

Manufactured in the United States of America
49344011
www.doverpublications.com

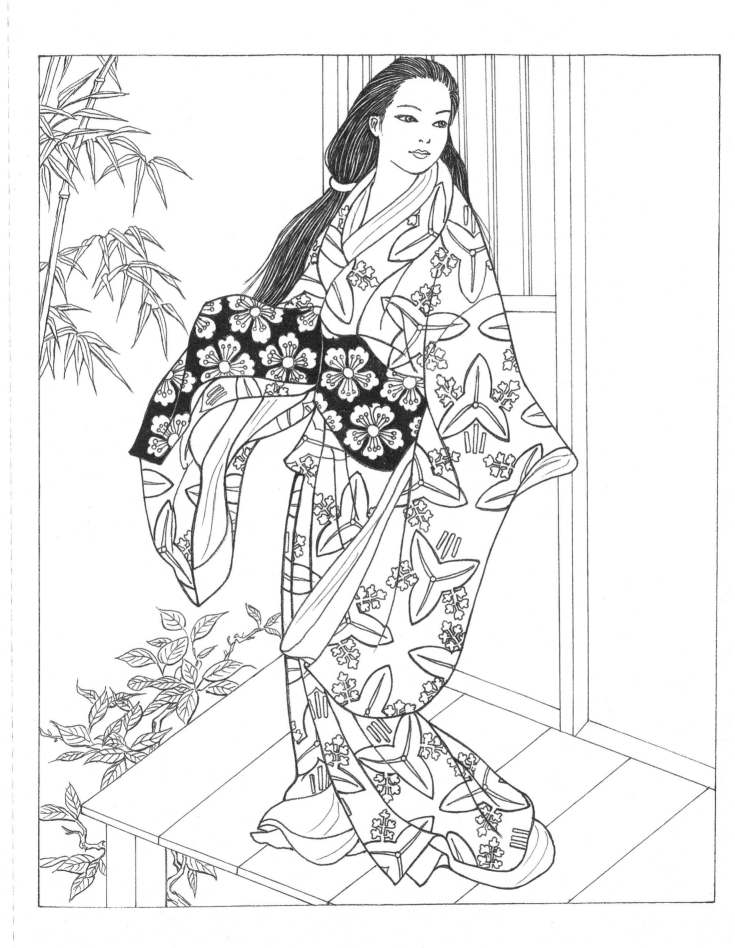

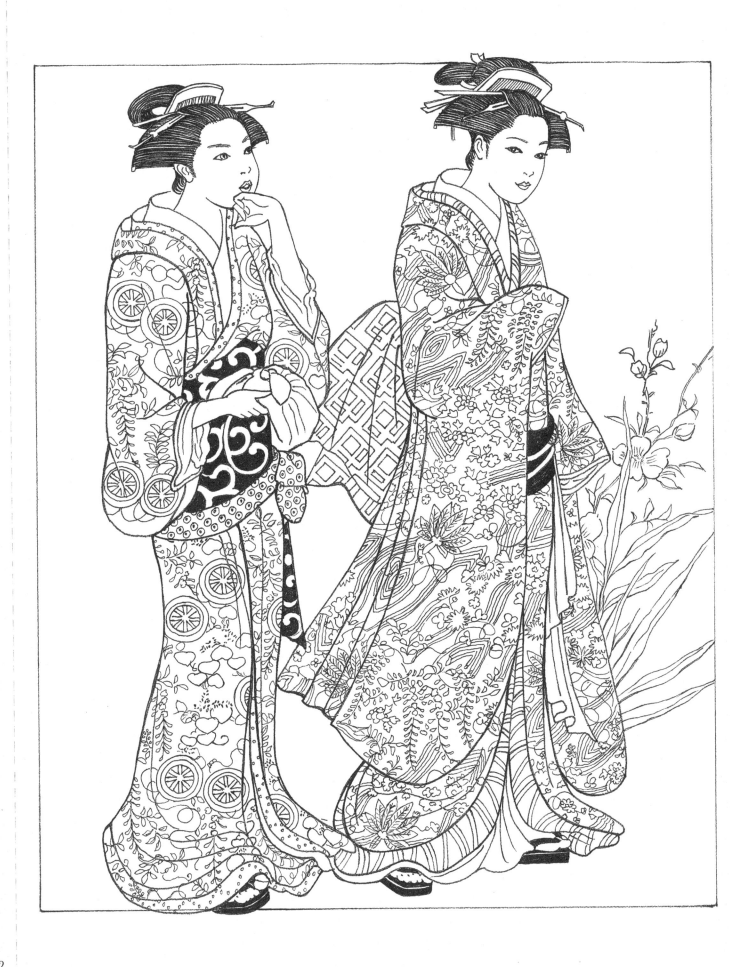

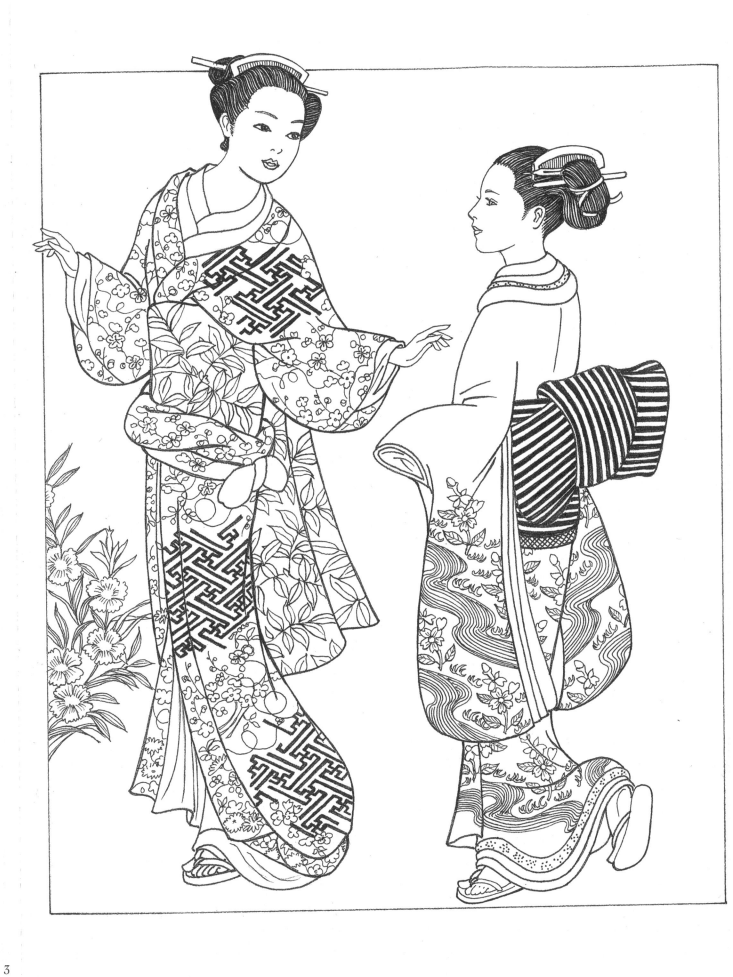

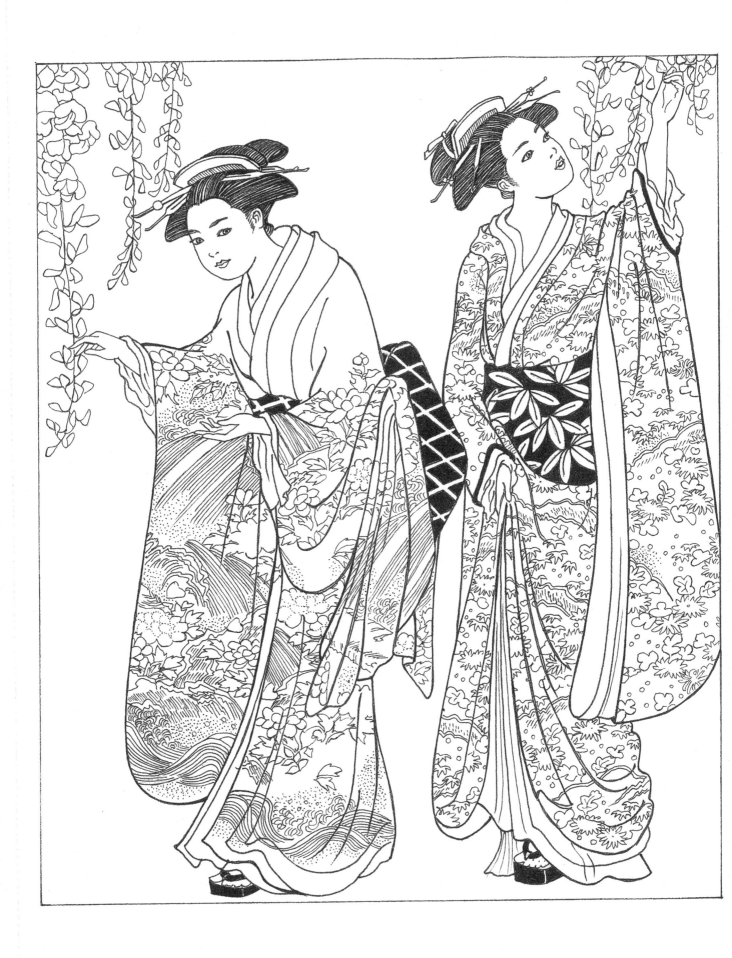

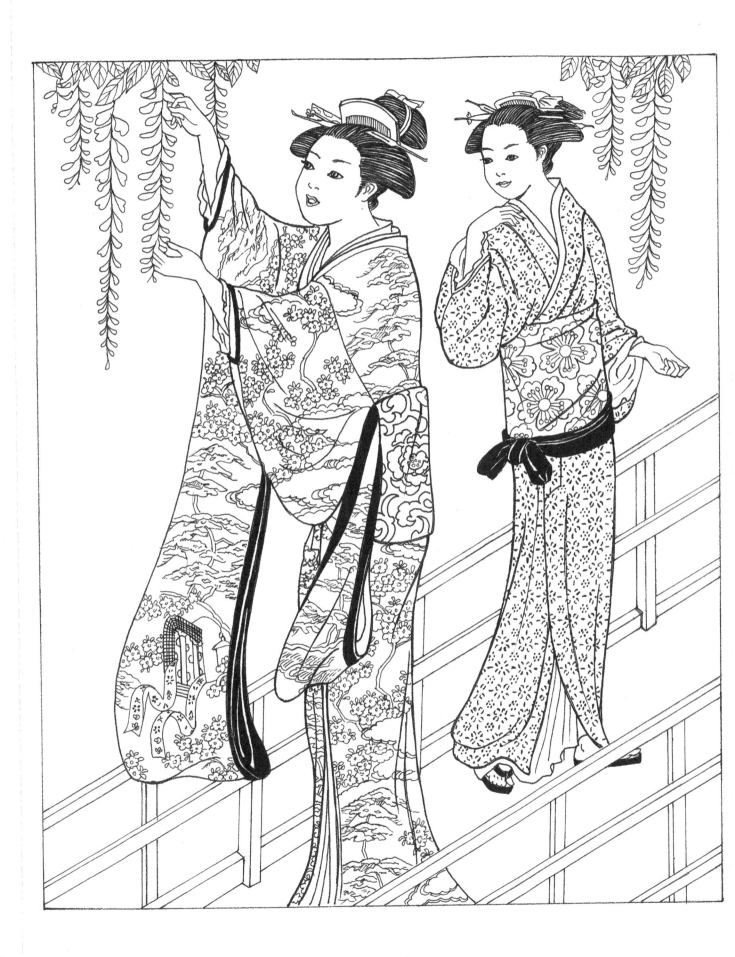

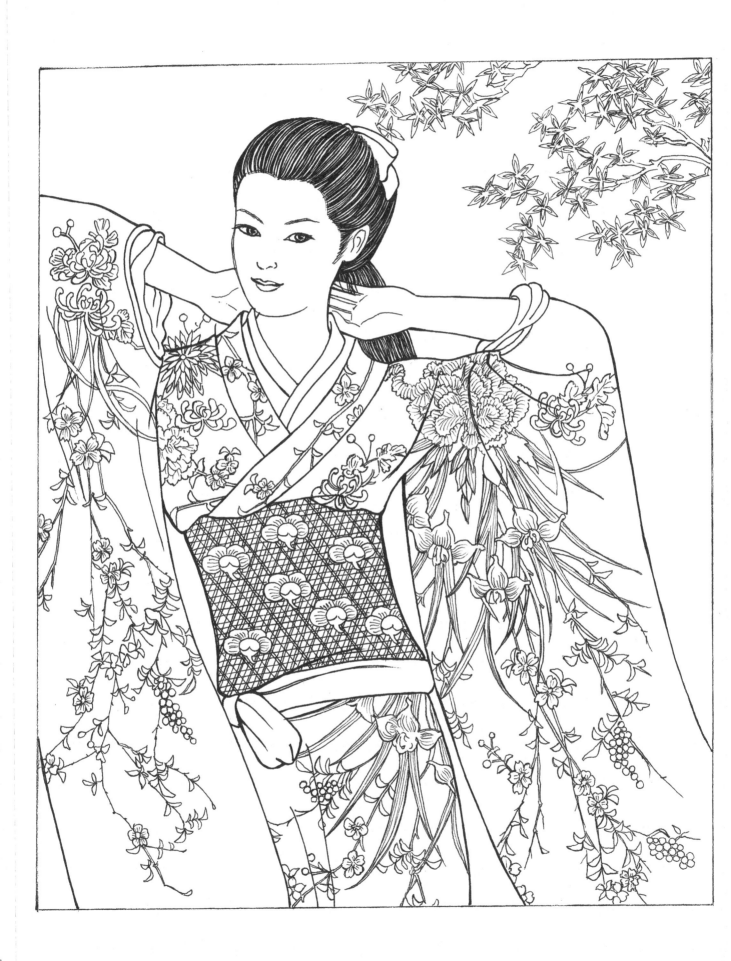

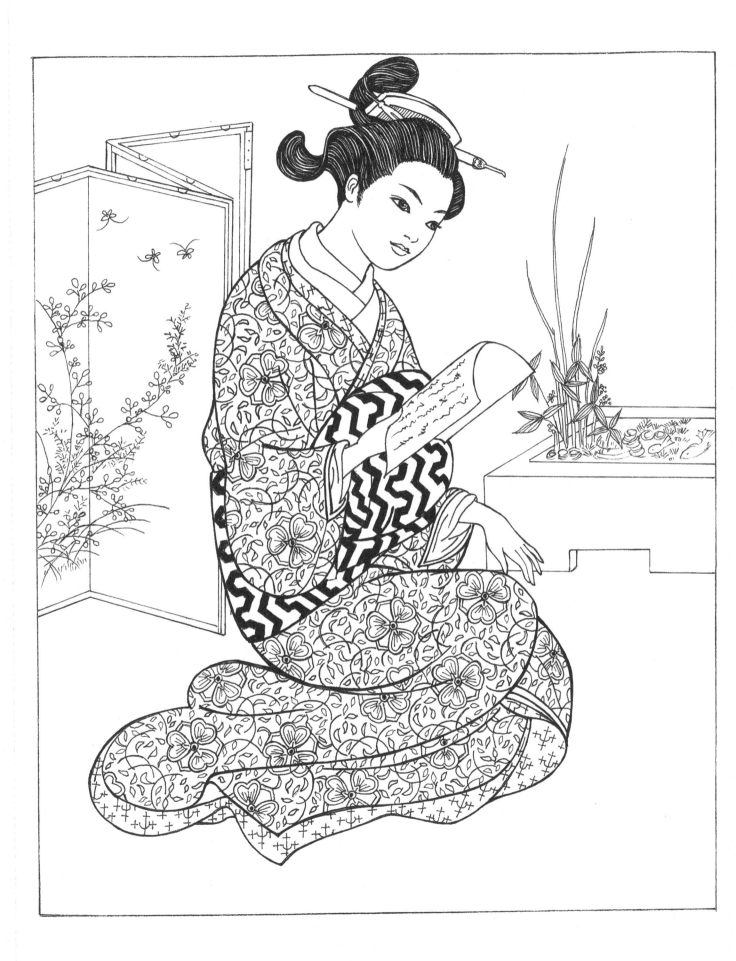

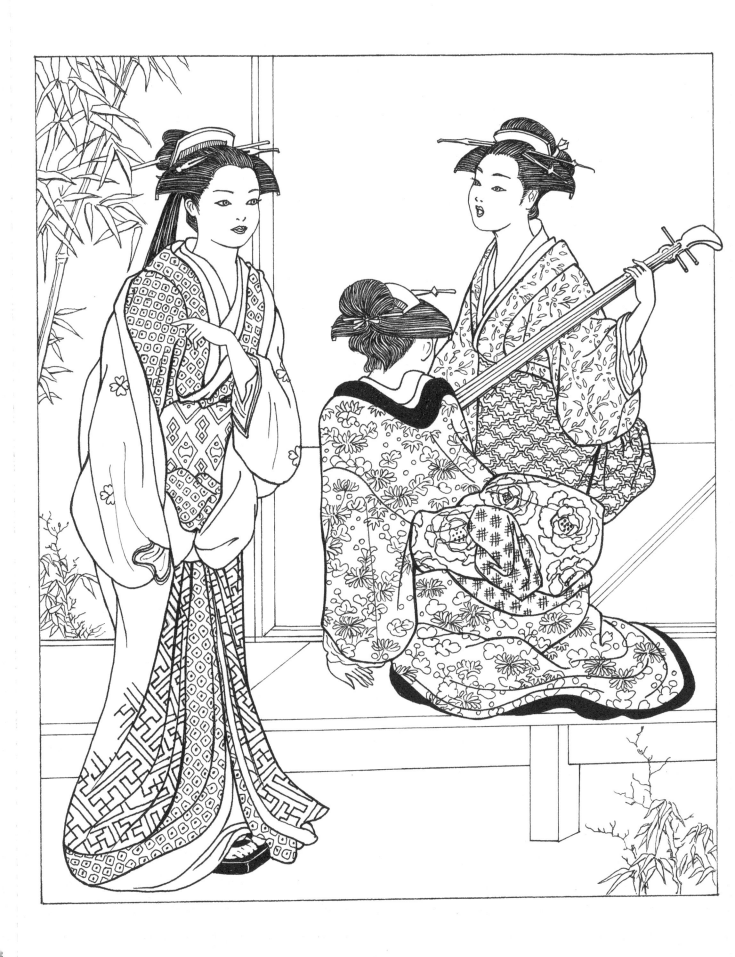

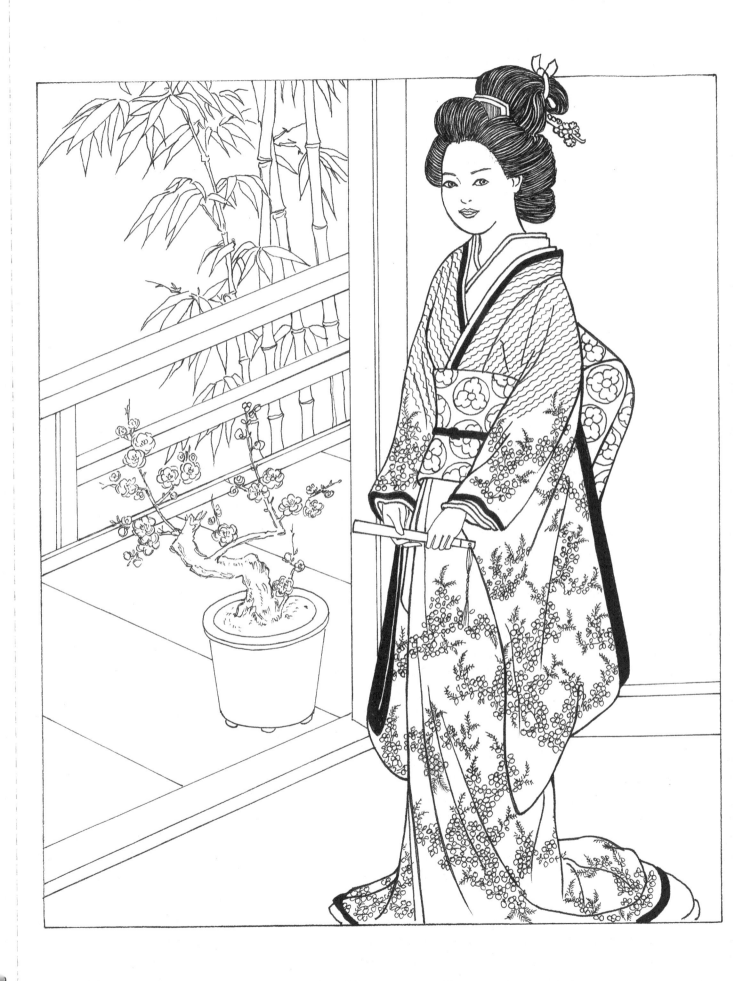

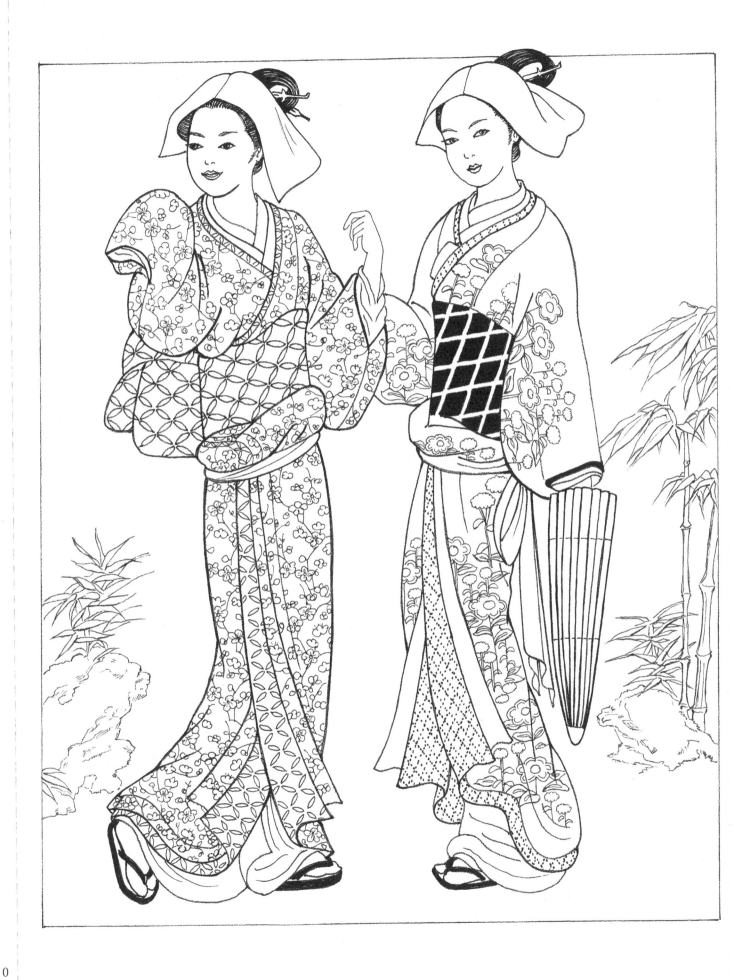

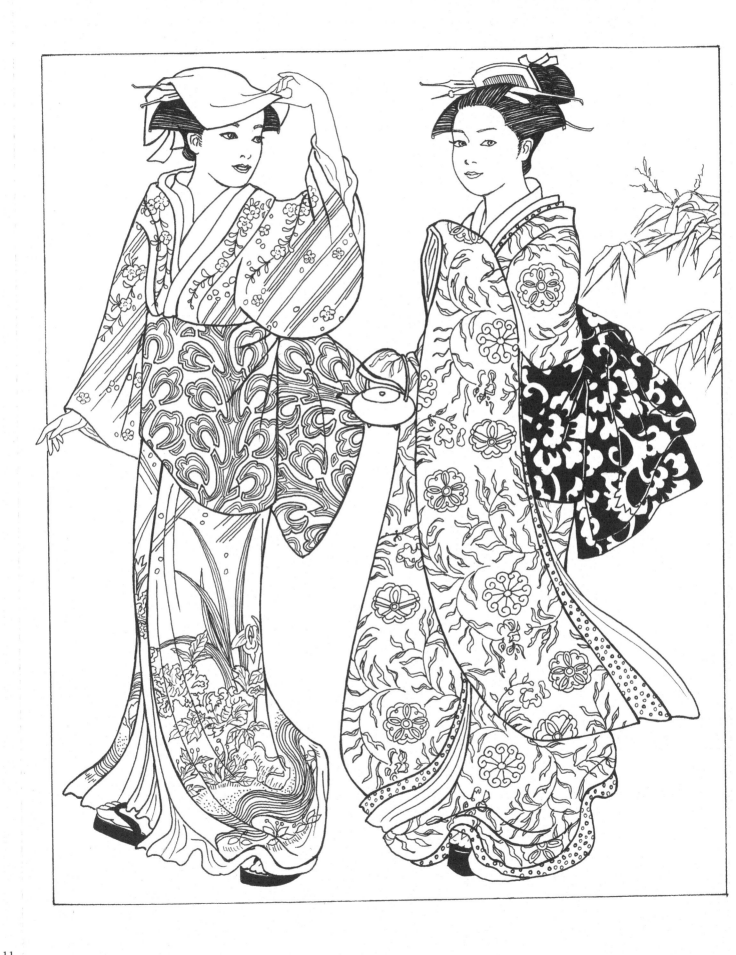

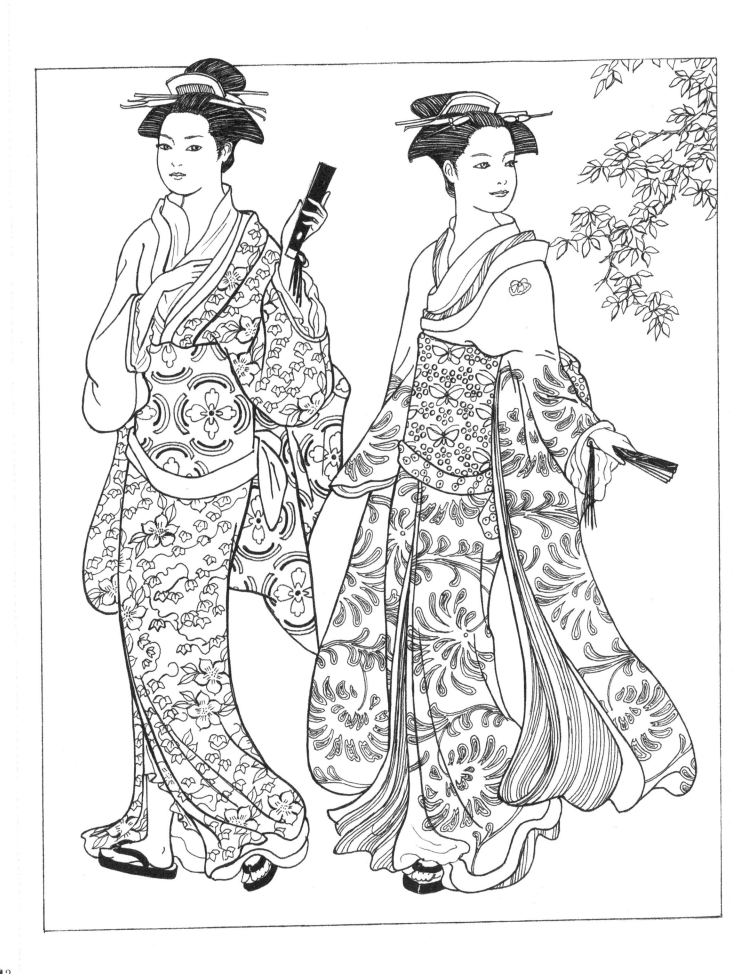

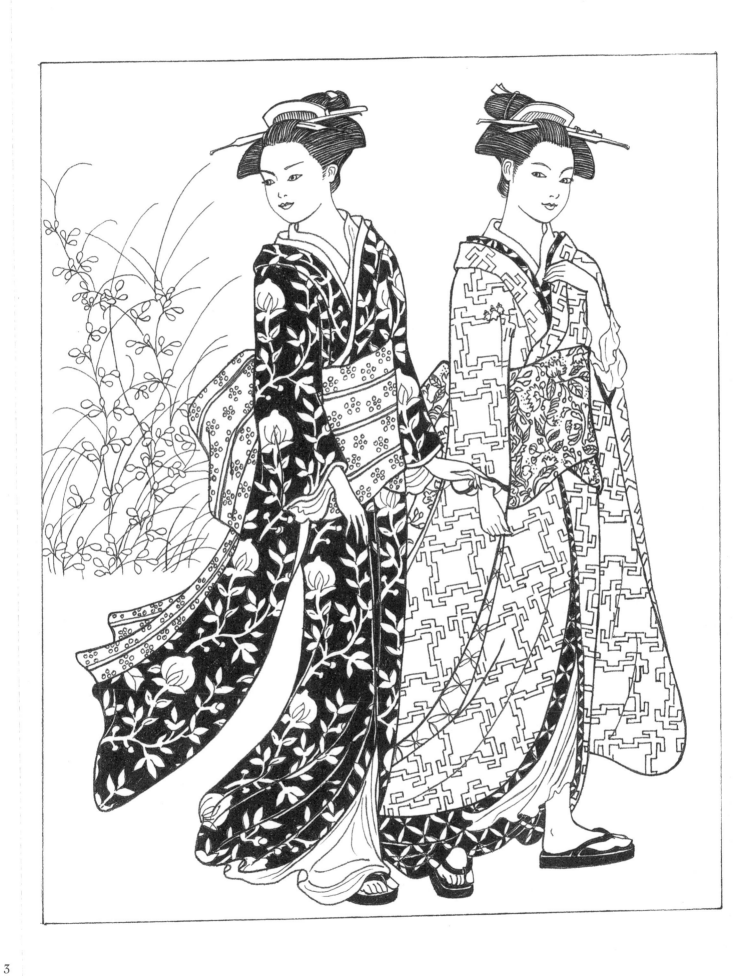

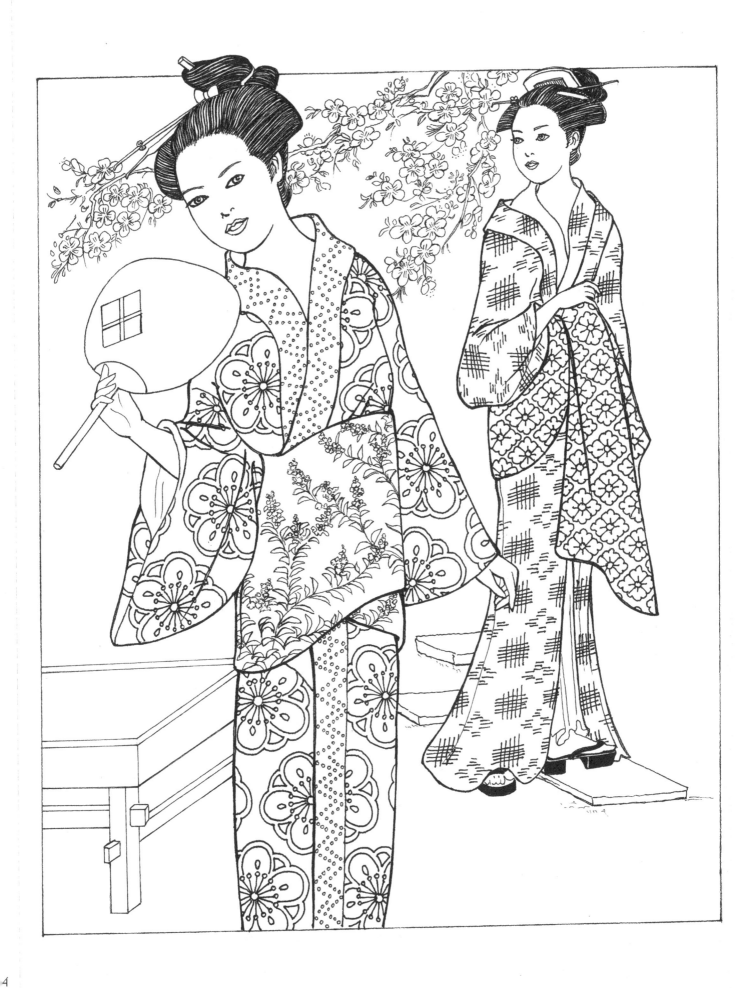

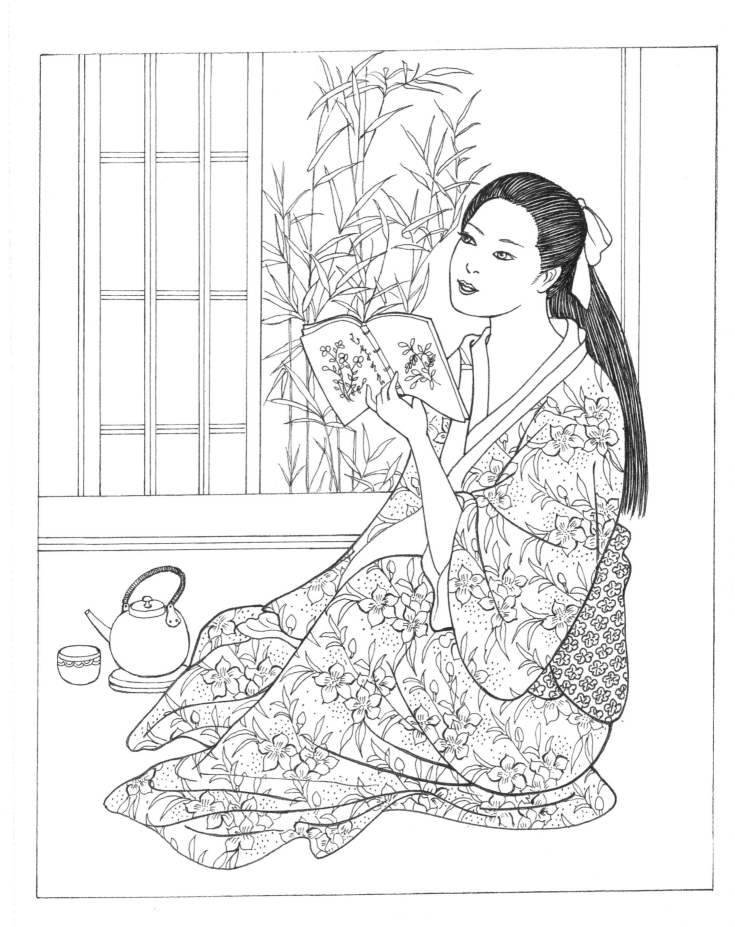

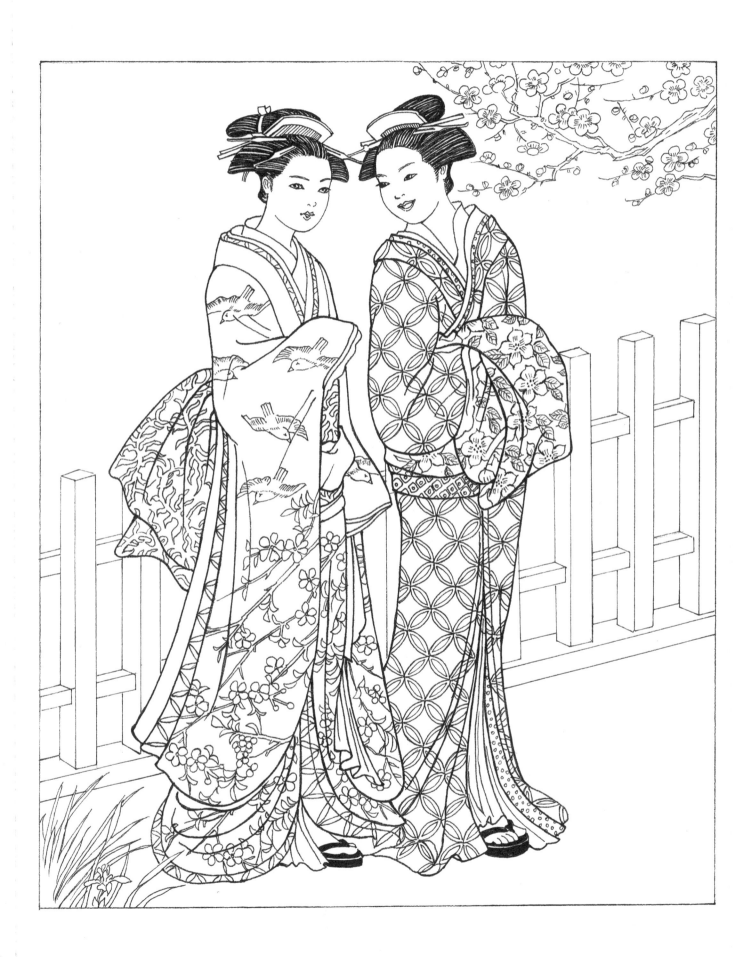

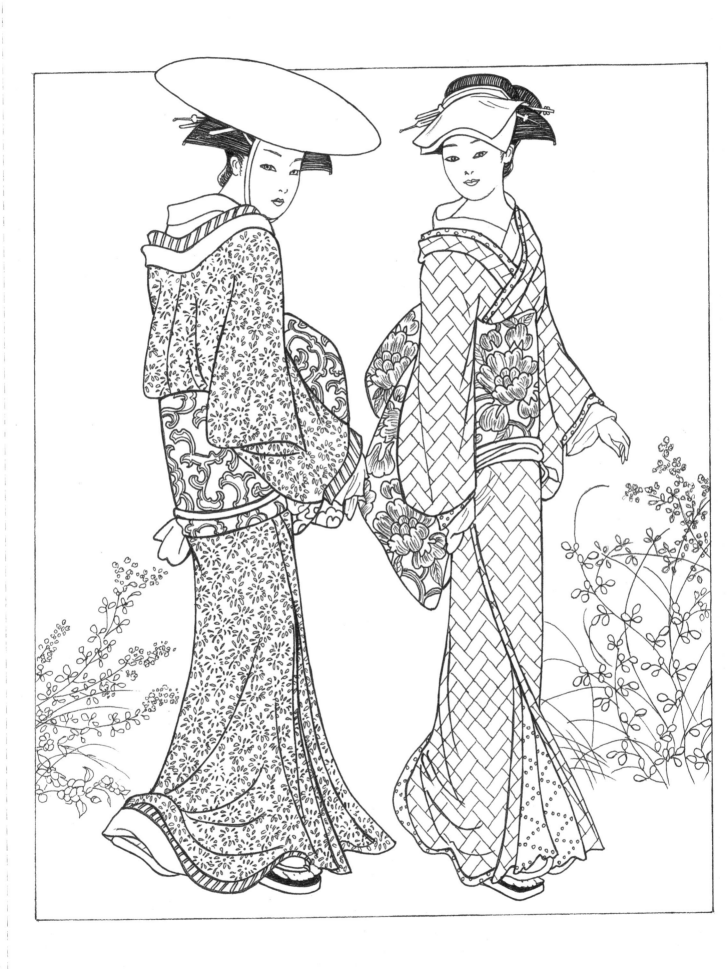

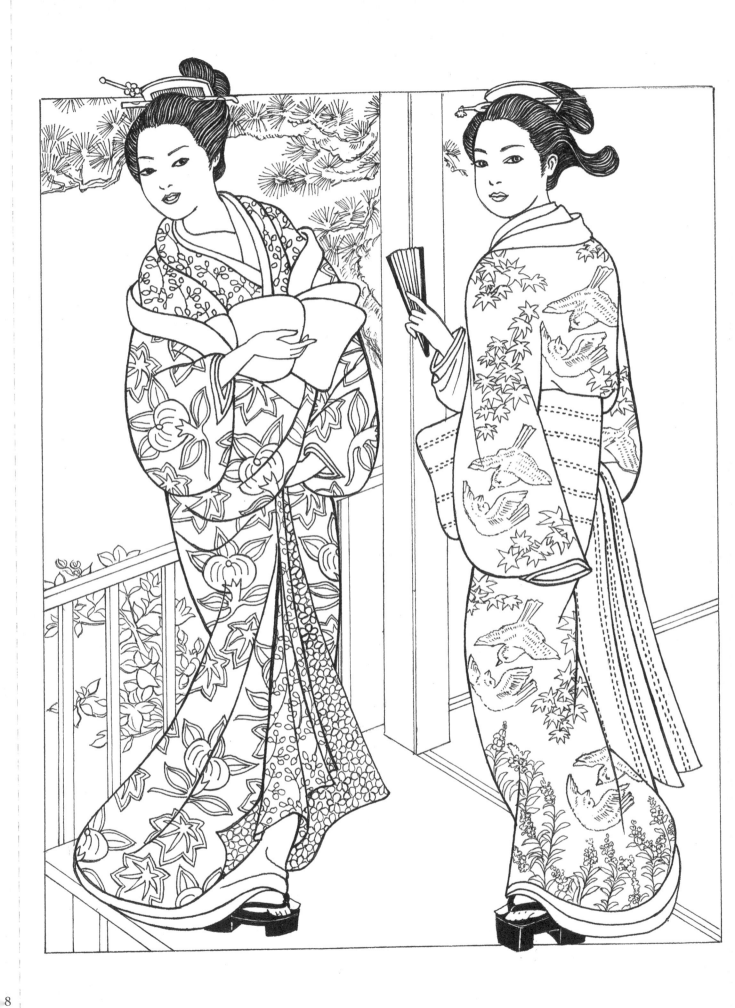

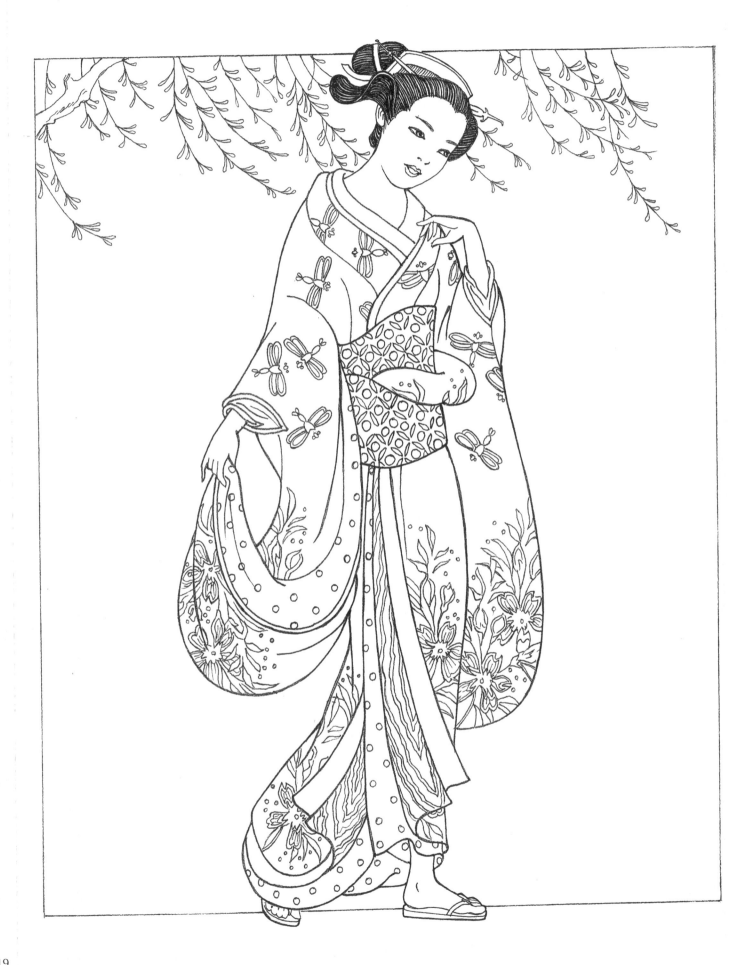

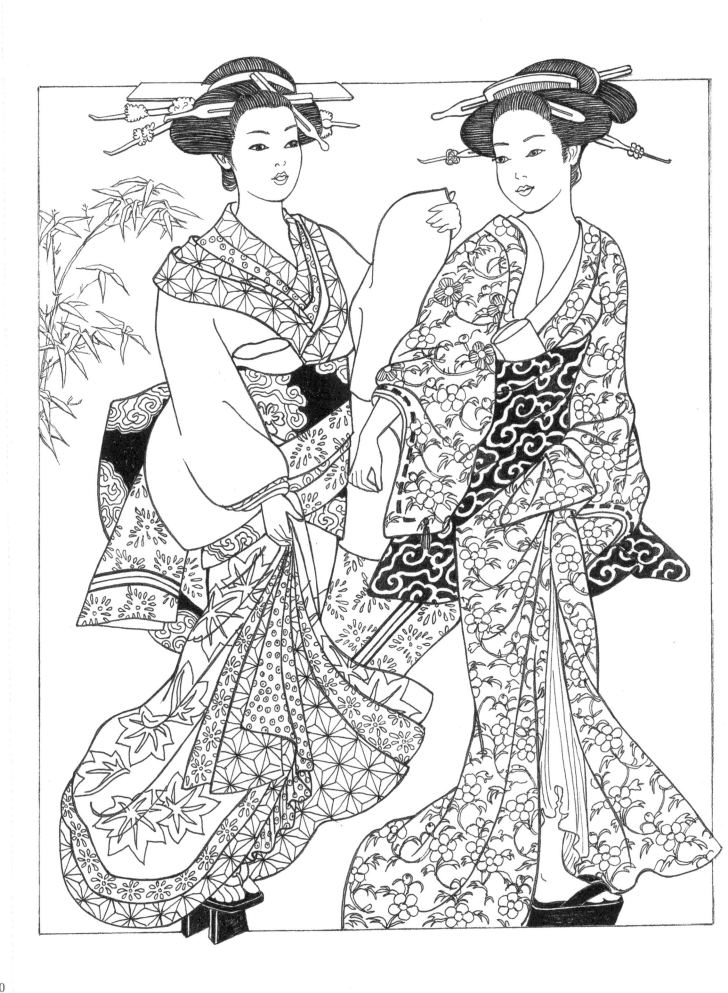

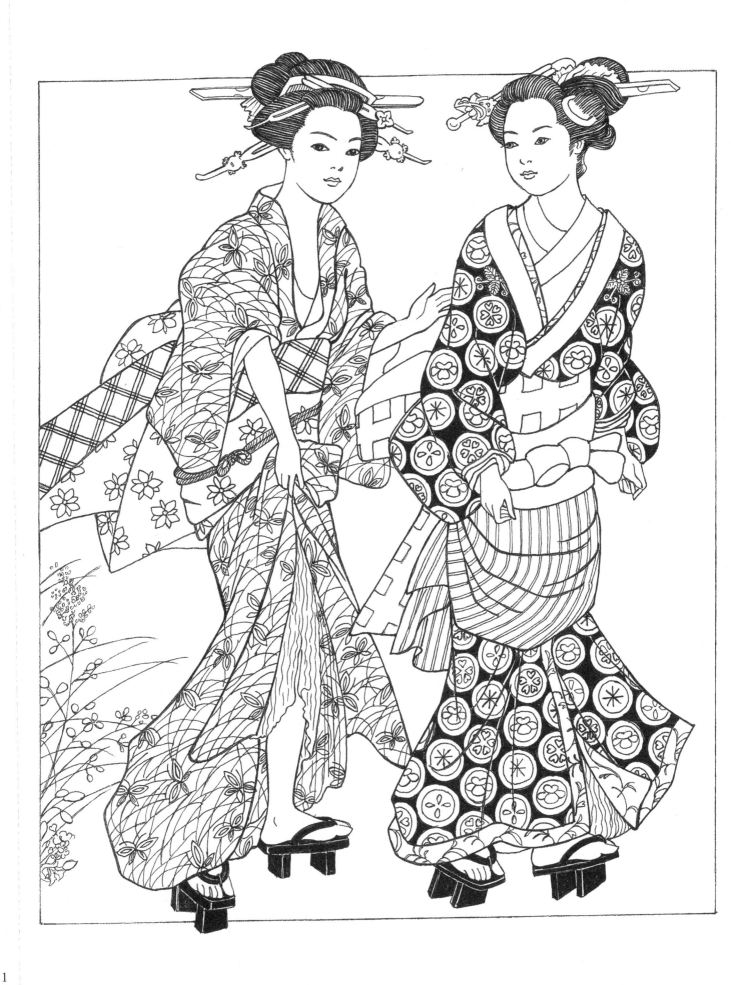

1

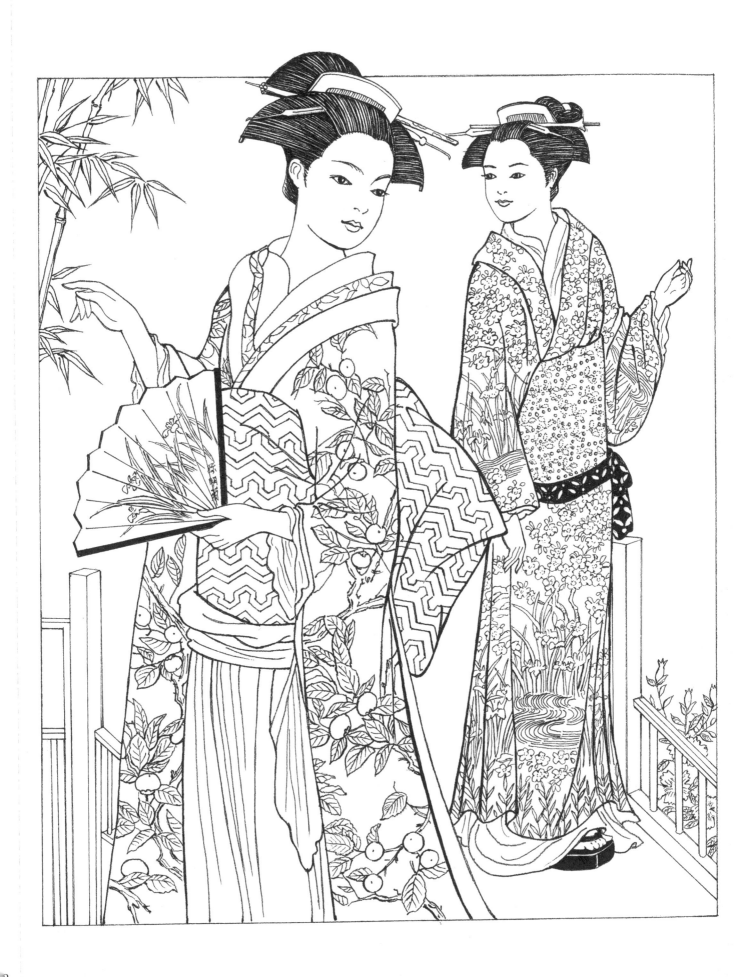

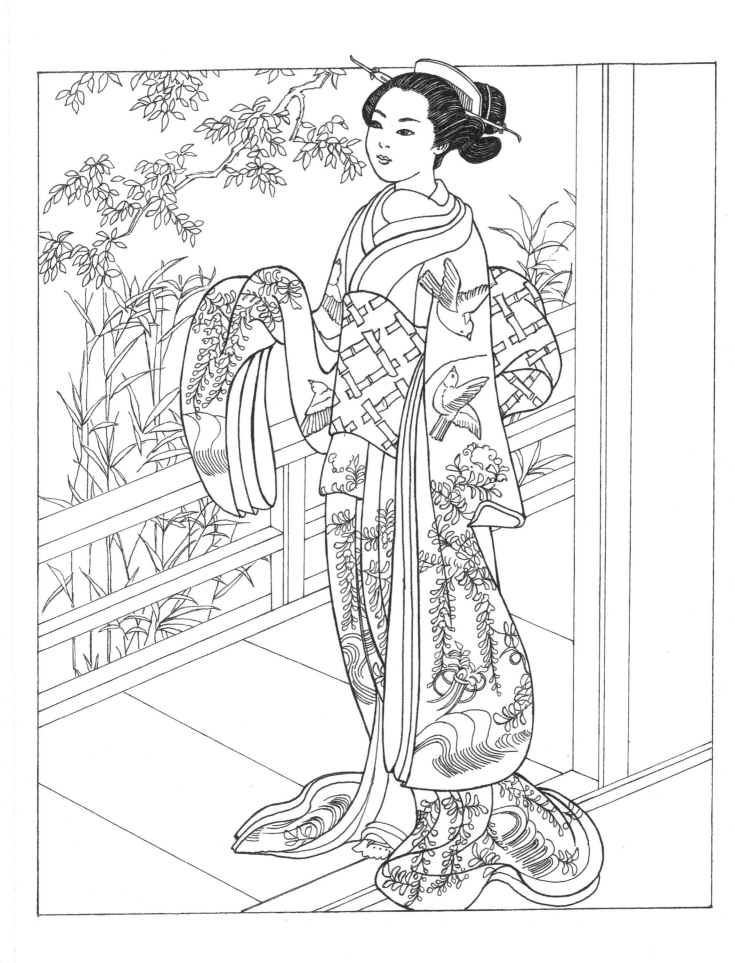

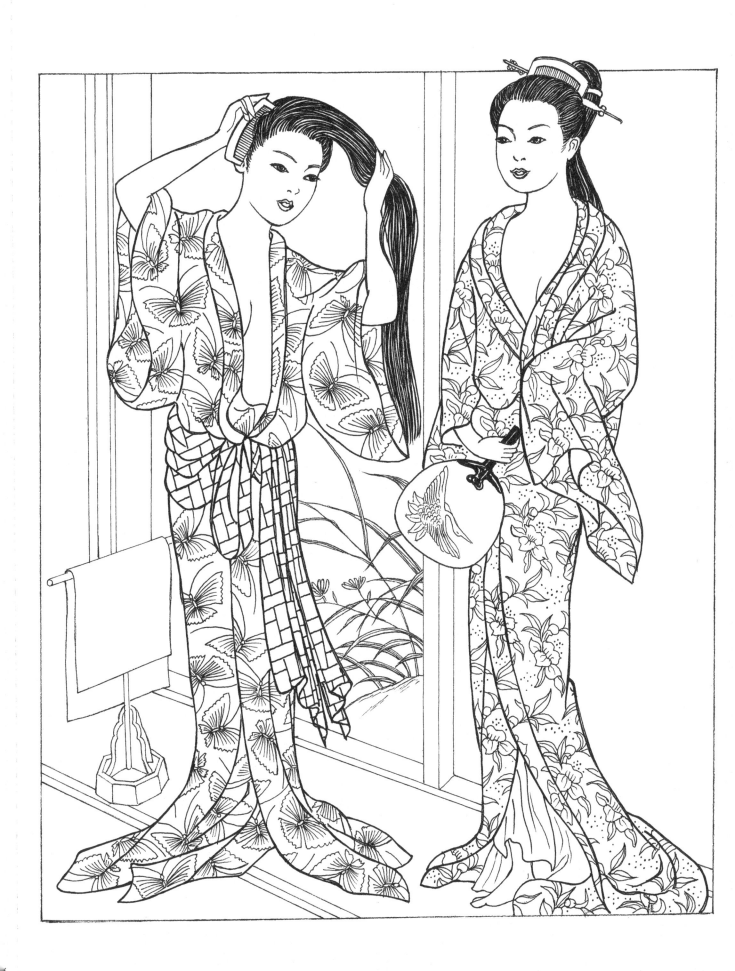

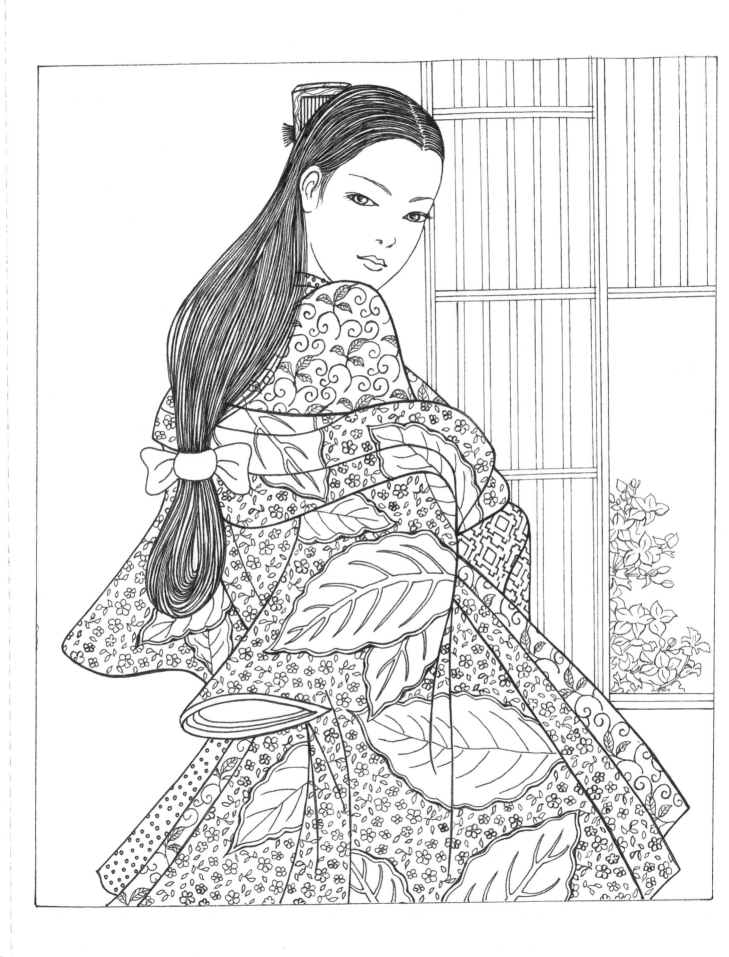

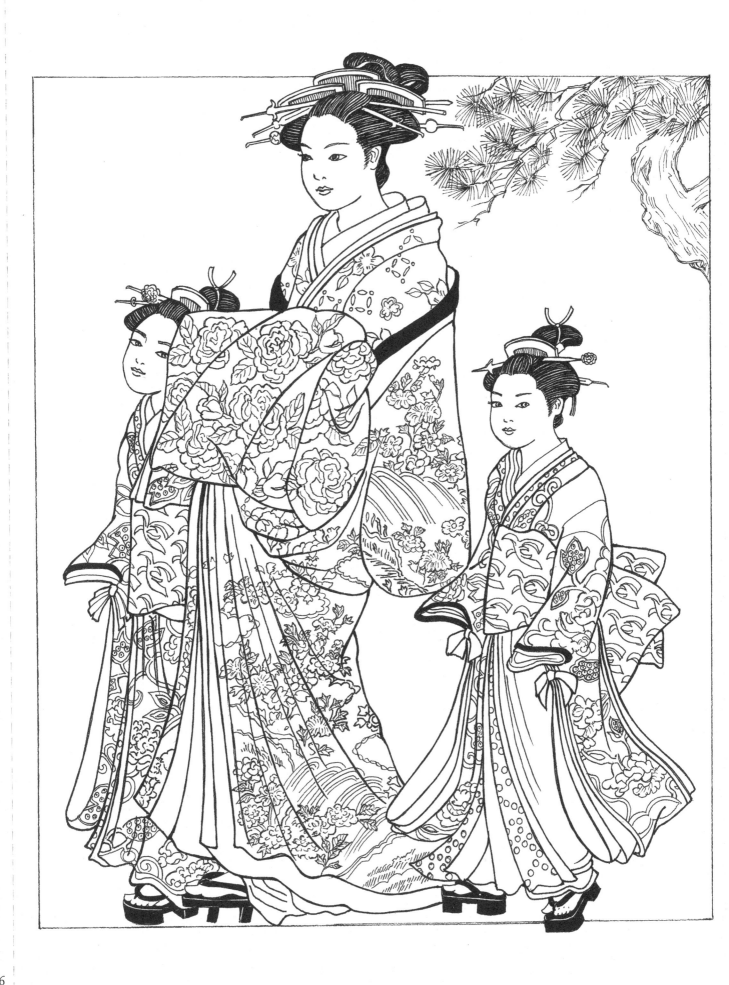

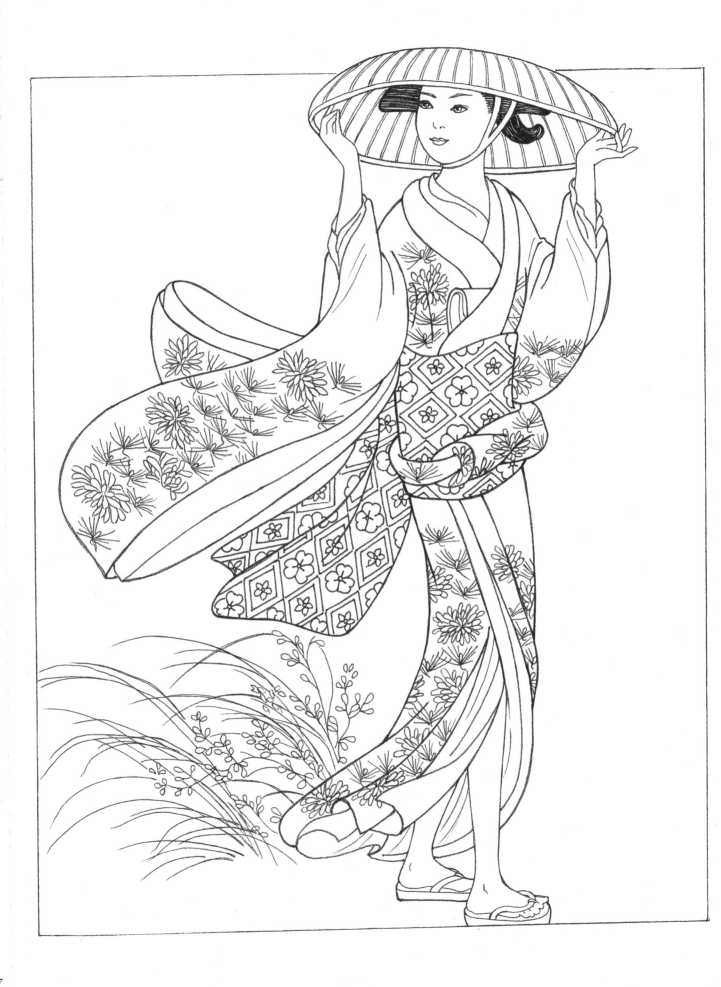

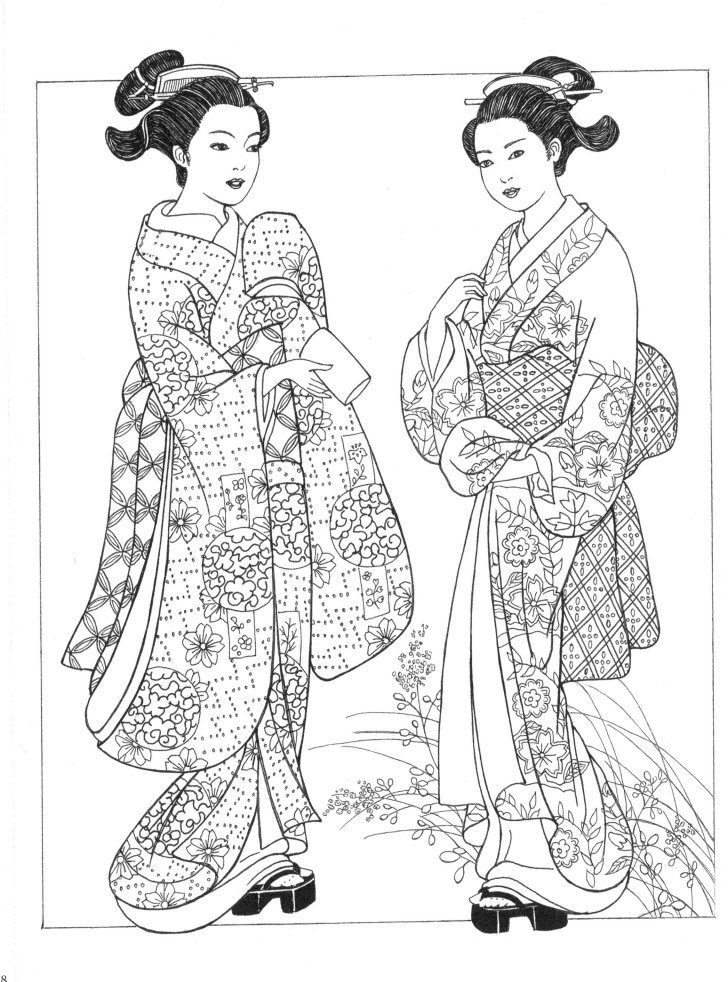

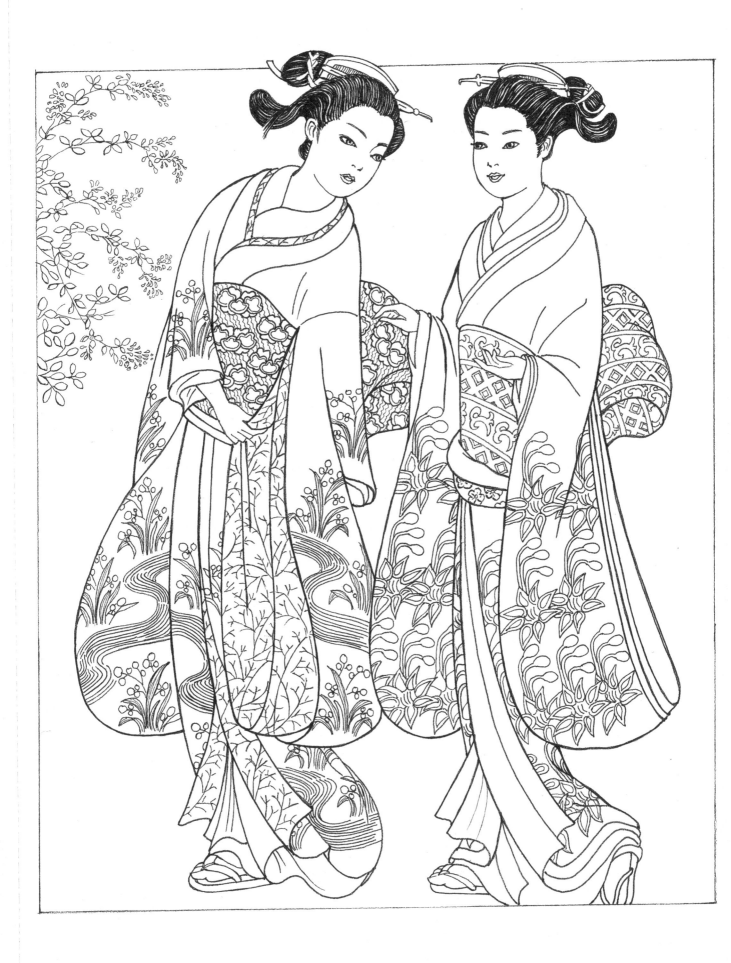

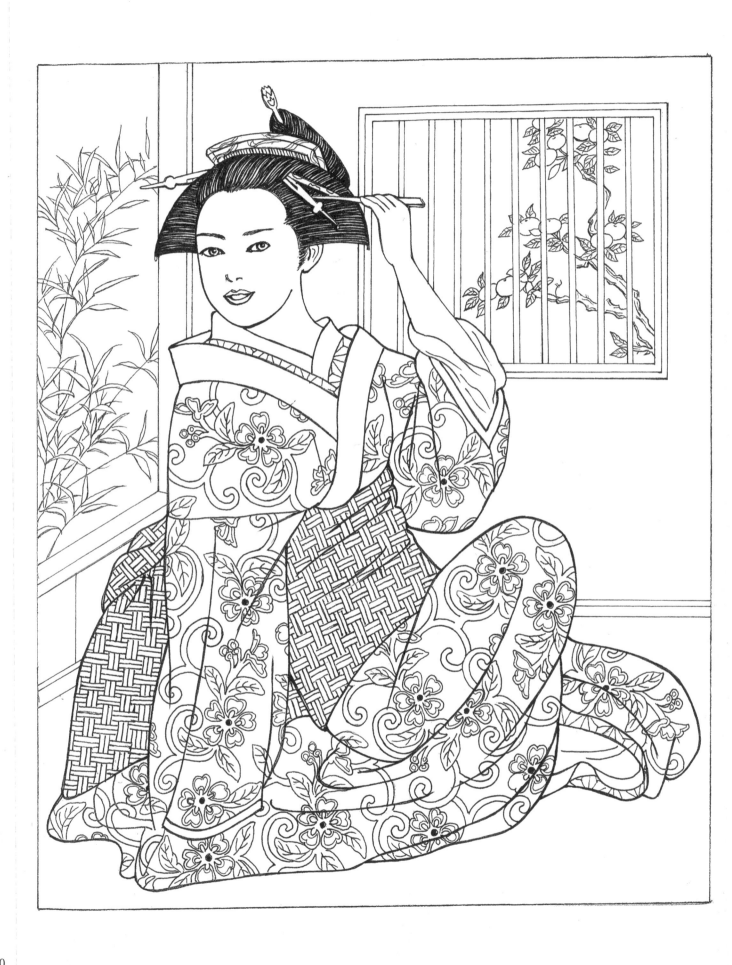

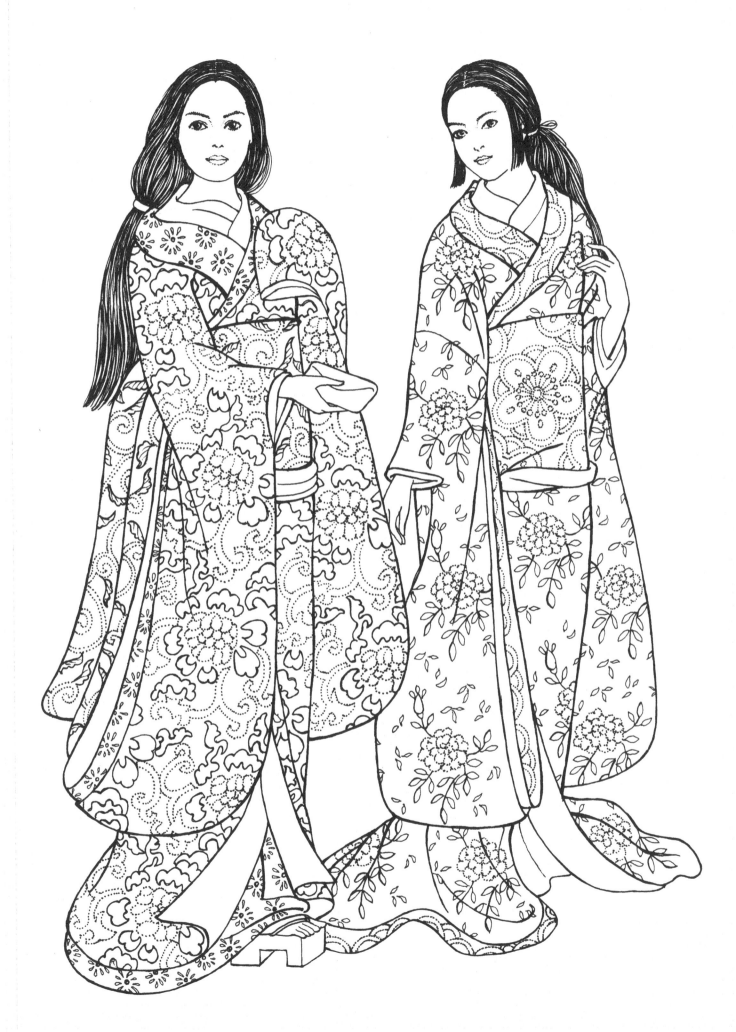